Praise For MARROW OF FLAME

These exquisitely crafted poems will fill readers with joy because they are proof that our spirits were made to awaken to the light. This work is a guide that can lead us into the depths of our own hearts and shows us the presence of the divine.

> —**Tracy Cochran,** co-author, *Transformations: Awakening to the Sacred in Ourselves,* contributing editor, *Tricycle: The Buddhist Review*

Dorothy Walters' poems are incandescent sparks struck from a soul placed between the hammer and anvil of life. Like all true poets she has endured loneliness, terror, grief, ecstasy, to offer us her distilled wisdom that reconnects soul with Soul. Like a surgeon, she removes the cataract from our clouded eye so that we can glimpse the Mystery. We should treasure such poets; today they are rare.

> —**Anne Baring,** co-author *The Myth of the Goddess; The Mystic Vision;* and *The Divine Feminine.*

What deep, sweet delight to taste the poetic nectar of Dorothy Walters' heart spilling over in the mysterious embrace—God and Soul / Beloved and Lover / One and Another / Self to Self.

> —**Gangaji,** spiritual teacher.

In this book it says, "Only the final forgiveness will take us to light." Those are profound, beautiful words to me. Such speech and insight—valuable to every human being—could only come from a soul that has tasted the marrow of God, and now wants to help others do the same.

> —**Daniel Ladinsky,** author/translator, *The Gift: Poems by Hafiz.*

Dorothy Walters' poems call from the fire, the light, call out from the darkness and from the sacred place that is known to be empty . . . each poem shaped by grace and great love.

> —**Janet Adler,** author, *Arching Backward: The Mystical Initiation of a Contemporary Woman.*

D0847106

Revealing a whole world of sacred treasures and nourishment, the poetry of Dorothy Walters flows in the great tradition of Rumi, Kabir, and Mirabai. Like her mystical ancestors, she descends over and over again to the fire that burns at the center of the Earth and emerges with Light in her hand. Some of her poems glow like candles where people kneel to pray; some shine like the torches of seekers in the night; others shimmer with the tranquil, holy radiance of the divine darkness. There is a new mystic in our midst, and it is sheer joy to read her poetry.

> —**Mary Ford-Grabowsky, Ph.D.**, author,
> *Sacred Poems and Prayers of Love*, and *Prayers for All People.*

These quietly but profoundly astonishing poems of Dorothy Walters have been summoned from the depths of a mature and generous soul. Each turns to us a different honed facet of the diamond of truth and each sings with the incandescent sincerity of the essential life of love that we all—whatever path we are on—have been called to live. I am awed by their passion and their craft, their artful simplicity, by the way they speak so nakedly the speech of divine human intelligence, and by the way they witness the heaven that is already on earth for those daring and abandoned enough to see and live it.

> —**Leila Hadley Luce**, author of *Give Me the World* and
> *Journey with Elsa Cloud.*

At the place where Madame Colette, Djuna Barnes and Rumi's souls meet beats the heart of Dorothy Walters.

> —**Eryk Hanut**, international photographer; author, *I Wish You Love.*

MARROW OF FLAME
Poems of the Spiritual Journey

DOROTHY WALTERS
Introduction by Andrew Harvey

HOHM PRESS
2000

Cover design: Kim Johansen
Layout and design: Shukyo Lin Rainey

Library of Congress Cataloging-in-Publication Data

Walters, Dorothy, 1928-
 Marrow of flame: poems of the spiritual journey/
Dorothy Walters; introduction by Andrew Harvey.
 p. cm
 ISBN: 0-934252-96-3 (alk. paper)
 1. Religious poetry, American. 2. Spiritual life--Poetry. I. Title.

PS3573.A472288 M37 1999
811\54--dc21

 99-089501

HOHM PRESS
P.O. Box 2501
Prescott, AZ 86302
800-381-2700
http://www.hohmpress.com

For Jeannine Keenan, Kit Kennedy,
and Patricia Lay-Dorsey, my three
muses, who lighted my way through
the labyrinth.

Andrew Harvey, beloved mentor and
anam cara (soul friend), who shared
so freely of rich and unexpected
treasures.

Eryk Hanut, who has always been there
for everything.

Tell me your passion

and I will name your god.

(Old Wisdom Saying)

CONTENTS

INTRODUCTION

by Andrew Harvey

Six years ago now I gave classes on Rumi at the California Institute of Integral Studies. After one of them, during my office hours, a gentle and shy woman with short-cropped gray hair in her early sixties came in to talk to me. Before she even began to speak, I was startled by the kind clarity of her presence, the unmistakable aura of canny and tried goodness that clothed her. We spoke of many things that afternoon—about Rumi and his extraordinary relationship with Shams, about the nature of mystical ecstasy, about the kind of rigor and capacity for ordeal demanded by the authentic path of transformation; it became clear to me very quickly that I had a great deal to learn from the woman sitting before me, and that she spoke not from curiosity, or even literary or spiritual passion, but from the most profound, intricate and seasoned inner experience. What struck me most that afternoon about Dorothy Walters was her humility; unlike many of my Californian students and friends, she did not claim enlightenment or flaunt her "mystical" insights. Part of her, I felt, was always kneeling in silence before the vastness of the mystery that had clearly claimed her for its own: she spoke of the Divine haltingly, and with a refined and poignant tenderness, like a lover of her Beloved. And she had a wild Irish laugh, too, which reassured me.

In the years since, we have become the greatest and deepest of friends and I have come to think of Dorothy as a spiritual mother and as one of the few true mystics I have met in my life. Her beauty of soul has illumined my life; her courage has inspired me always to travel deeper into my own vision; I have been able to

speak to her, as a fellow seeker and lover of God, with complete candor about the demands of the Path. When I left Meera in circumstances that caused great scandal and controversy, Dorothy wrote me a letter, which I shall always cherish and re-read often, in which she begged me to "remain true to myself whatever happens and never to give in to any of the terrible pressures my actions and insights will inevitably arouse." It was the perfect advice, perfectly expressed, at exactly the right time; this kind of precision characterizes Dorothy's spirit. The only other being who in my experience combined such deep kindness with such wisdom was Iris Murdoch; one of the great sadnesses of my life is that Iris died before they could meet. When I think of them together I think of the commentary the *I Ching* gives on the sixth line of the hexagram Ting, "the Cauldron." "The Ting has rings of jade." "Jade is notable for its combination of hardness with soft luster...here the counsel is described in relation to the sage who imparts it. In imparting it, he will be mild and pure, like precious jade."

It was only after the first two years of our friendship that Dorothy began, diffidently and self-deprecatingly, to show me the poems she was writing. I was immediately struck by them; they were exquisitely made, subtle, passionate and profound, unlike anything else I knew that was being written in our time. Whenever we met, Dorothy would bring some fresh works to our meeting. Slowly, as we read them together and discussed them, Dorothy came to reveal more to me of her remarkable inner journey; a journey that has led her through much ordeal and heartbreak and loneliness from a cramped and sometimes difficult childhood, through a long, testing stint as a teacher of literature and women's studies in a mid-western university, to the festive and fertile spiritual and personal life she enjoys now in her very active "retirement" in San Francisco, surrounded by books and music and friends.

Three years ago I summoned up my courage and asked Dorothy to write to me and describe her mystical voyage in her own words. This is part of what she wrote:

> For most of my life, I have sought ways to be in touch
> with what is sometimes called the Mystery—the truth

that underlies the appearances of the many things, the reality that provides the hidden basis for the manifest world of the senses. In childhood I experienced this connection on a deep intuitive level in the world of nature. I lived close to open fields and gentle rolling woodlands. Each excursion into these precincts was, for me, an entry into terrestrial paradise.

artist's relation to nature

In her letter, Dorothy goes on to describe how, in her adolescence, she went through what she calls her "first" spiritual conversion:

In adolescence, I discovered Emerson and Thoreau as well as Plato's myth of the cave. These spoke to me on a profound level, and, under the guidance of a highly spiritual teacher of transcendental literature, I underwent a classic Christian conversion. I felt a renewal akin to rebirth and saw the world with cleansed eyes. Love, grace and beauty suffused all which lay about, including the most common objects—pebble, leaf and stone. The universe revealed itself as a reflection of divine intelligence, and all things conspired for ultimate good.

art as religious (conversion) experience

This early conversion experience dimmed, however, during Dorothy's graduate school years—the first of many spiritual "deaths" that she has weathered. "From 1953 to 1960 I was a student of English and American literature at a midwestern university, at a time when women were not encouraged to pursue advanced degrees. Like most of my colleagues I embraced a more "intellectual" approach, adopting an elitist skepticism which challenged whatever was not subject to rational inquiry and investigation."

This "skeptical intellectual" approach began to crumble during the 60s and 70s when Dorothy became established as a university professor in English and women's studies. As she wrote to me: "I began to read widely in psycho-spiritual literature, some of which was just emerging: Carlos Castaneda and Carl Jung, Joseph Campbell, Mircea Eliade...and especially the poetry and occult writings of W.B. Yeats. I delved into the workings of the Golden Dawn and read and re-read Evelyn Underhill's classic

writings on mysticism. This background helped to awaken in me a sense of psychic reality beyond the bounds of ordinary consciousness and in my forties I underwent a fairly explosive psychic opening."

This "fairly explosive psychic opening" led Dorothy to experience telepathic communication, the reality of auras and inner lights and visions, and included "contact with a specific spiritual guide." She studied tarot, astrology, and Kabbalah, and engaged in Ouija work and quasi-automatic writing. The poetry she had always written casually now became focused on the inner journey, "drawing inspiration from the archetypal images of both the goddess and the hero."

Her esoteric investigations disturbed her however; "I ceased to explore them further after one particularly unsettling experience. (Who were these forces really? Where had they come from? Was there any truth to their pronouncements, any purpose to these manifestations?) For the next seven years I shunned occult realms and wrote primarily on academic themes."

This "shunning of occult realms" for seven years did not however "shut down" Dorothy's inner journey; in fact, it seems to have been the mysterious prerequisite for the experience which she acknowledges as having been the determining illumination of her life. This is how she describes in her letter what happened to her:

> In 1981 I experienced an inner emotional crisis which culminated in an abrupt, profound and totally transfiguring Kundalini awakening. One Sunday morning, in late May, I was reading in my living room in the mid-western university city where I taught; the sun was streaming in through my high clerestory windows, the elm-lined street was quiet. I was now fifty-three years old, and facing the imminent breakup of a long term relationship. To me the prospect was devastating, more than I could bear to contemplate. Once again I had failed to achieve a permanent relationship. Once more I was undergoing a kind of spiritual death...
>
> The book I was reading that day mentioned Kundalini but did not describe it in detail. It spoke of the ancient yogis who could raise the "serpent power" from the

base of the spine to the head. On impulse, I decided to see if I could lift my own energies this way. I meditated on an image of the god and goddess in union (from an illustration in the text) and focused on my breathing. Almost instantaneously I felt a great surge of ecstatic energy in the lower chakras and then, within seconds, this intense force rushed upward and into my head. My very crown seemed to open in rapture, and, for many minutes, I felt the energies of the unseen immensity flow in, as if petal after radiant petal were unfolding in my crown. As long as I did not think about what was happening, the experience continued, but each time self-awareness intruded, the process was interrupted.

In that moment of grace, I realized that the notion of personal identity was an ongoing illusion, a myth the small being recites to itself in its state of lostness and isolation. I knew that we were each one but atoms within the larger frame, the boundless real...I did not return immediately to ordinary consciousness. I remained in a state of exalted awareness and rapture for months thereafter. I seemed to undergo a prolonged initiation directed by unseen inner guides...I saw the light around my body and heard my new name.

Everything was now lit by an inner beauty surpassing everything I had experienced before. Every face was my own, every leaf or bloom an aspect of my being. I felt that I had, at last, fused all levels; I knew, finally and incontrovertibly, that spirit and flesh are one, matter and the transcendent but differing faces of a single essence.

expression of mysticism

In the almost twenty years since her Awakening, Dorothy has undergone a great deal of battering physical and mental stress; as all those who have experienced an overwhelming arousal of the Kundalini know, it can take decades of humble, often baffling, inner work for its initiations to begin to be integrated in body and spirit. Perhaps the greatest difficulty Dorothy experienced, especially at the beginning, was her

isolation; her "Awakening" occurred when she was teaching in Wichita, Kansas, a place not noted for its proliferation of free-thinking mystics. Joining any kind of sect or putting herself under the guidance of a guru was foreign to Dorothy's temperament; "from very early on," Dorothy told me once, "I knew that I would have to travel alone. A part of me rejoiced; another part of me almost fainted away with terror."

Despite all difficulties and obstacles, however, through all the minor and major ordeals of the transformation she has submitted herself to, Dorothy has kept doggedly faithful to the supreme lessons her Awakening taught her; now in her early seventies, she has, I believe, achieved a rare and high fusion of her feminine and masculine energies, of wisdom and compassion, gravity and delight, inner prayer and outer service. She is coming into what Rumi so beautifully calls "the Sea of Peace in which all ships find safety at long last;" to be in her presence is to be in the presence of someone who has been through a long, sometimes terrible, hidden war and who has won through to an authentic, sober but electric radiance and the grace of God. The young girl finding the terrestrial paradise in the fields around her home has become the older woman increasingly at one with the Divine in all her movements, subtle actions and tender humor.

I have explored Dorothy's wonderful journey here at some length because it everywhere illuminates *Marrow of Flame*. This unique book of poems is the record of the discoveries, visions, ordeals, and integrations of her long journey to Wholeness. Its mysterious authority springs directly from the intricate and lived depth, range and passion of Dorothy's inner experience. The "voice" of *Marrow of Flame*—at once quiet and inexorable, gentle and wild, "feminine" in its intimacy and "masculine" in its power and sometimes brilliant certainty—is the voice of Dorothy herself, of Dorothy's transforming self; it is the voice of a person turning to gold through the long alchemy of Divine Love. The poems of *Marrow of Flame* are recognizably that of a modern woman and seeker; there is nothing archaic about their diction or presentation or sphere of reference; yet they are also timeless and often "sing" with the unnerving directness of the ancient mystical poets, such as Mechthild of Magdeburg, or Mirabai, or

[handwritten margin note: artist reflects their time period while touching a timelessness]

Ramprasad. What Dorothy has accomplished in this subtle and ravishing masterpiece is something that many modern poets have been struggling for but without success—a book of poems that work both as canny literary artifact and mystical utterance and inspiration. The years will reveal what a prophetic achievement this is.

There are three things I am especially grateful for in these poems. The first is their unfailing craft, the reward of decades of study of English and other literatures, and humble daily practice in different forms and genres. No one achieves so transparent and so sharply and exactly cadenced a living "voice" without immense work and literary acumen. Dorothy's command of all the "tricks" of the poet's trade—from buried half-rhymes to gorgeous and dazzling natural imagery to long, looping and overlapping melismas of syntax—is all the more impressive for *craft* being so "hidden"; at no point does "manner" ever overpower *& essence* "substance." All her artifice as a "maker" is at the service of the higher and more important truths she knows and is trying to honor. She is far too enamored of the initiations of silence to over-privilege the games of language; yet the words of her finest poems shine with this silence, as the moon does, reflecting a secret sun.

The second aspect of *Marrow of Flame* that I am profoundly moved by and grateful for is what I can only call its "spiritual honesty." In a time of grotesque and vulgar mystic "hype" and inflation, the sometimes hesitant, exploratory clarity of the voice of these poems comes as the most vivid refreshment. Rumi used to say that you can tell an authentic mystic by the "sear-marks of the Flame of Love on their faces and hearts." Such "sear-marks" are everywhere evident in *Marrow of Flame*. Dorothy has fought and suffered greatly, as most true mystics do, for her illumination, and can communicate to us—without frightening us—just how much the Quest costs and what resources of courage, self-knowledge, and abandon you have to summon from deep within yourself to be able to continue it. Repeated readings of *Marrow of Flame* will reveal to any sensitive reader what it represents: a massively experienced and accurate spiritual "autobiography," the record, shameless but unhysterical, of an extreme love affair with the Divine.

Unlike many modern so-called "mystics," Dorothy does not claim anything like total enlightenment, or parade her ecstasies as guaranteeing her any special election: she knows far too much not to know that the authentic journey is into a deeper and deeper humility, a greater and greater awe at the Divine, and has and can have no final "end" in this or any of the other worlds or dimensions. As Dorothy said to me once, "I have discovered that we are always traveling onward. The higher and further we travel, the lighter we become." These poems of *Marrow of Flame* have the "transparent lightness" of the "high" traveler; they wear their wisdom with the casualness of consummate tact.

The third power of these poems that I want to celebrate is their "initiatory" intensity. They themselves are the crafted births of a prolonged and continual initiation into divine reality: their candor is the candor of the emerging Divine Self speaking of its passions and discoveries directly; they not only incessantly invoke the Divine Light in all of its colors and modes and operations but are themselves mysteriously saturated with its energy. Anyone who reads these poems with an open soul will find themselves being led, as if by the hand, into the depths of their own most profound visions, insights, dreams and revelations and will receive, almost without being conscious of it, the most vivid kind of inner encouragement. As Dorothy writes in "Order of Melchizedek":

encounter w. the poems is an experience of the Sacred

> Know who you are.
> Do not debase the name.
> Carry it in your heart,
> a root flame of love.
> Walk through the world in silence.
> The moment will come.

This "initiatory intensity" of *Marrow of Flame* is all the more powerful, I believe, because it streams from the work of someone who does not in any way seek the status of a "master" or "great mystic." Dorothy's deepest wisdom—and the deepest wisdom of her poems—is that of an irradiated "ordinariness." She knows—and her poems show that she knows—that the greatest of all human achievements is to become one's own complete integrated

divine human self in the core of ordinary life where, as she writes in "Still Life":

> Each movement,
> each quiet gesture,
> awakens
> a rosary in the blood.

This knowledge of the inherent sacredness of "ordinary" reality pervades *Marrow of Flame* and grounds its ecstasies and wilder revelations. We trust Dorothy as a guide to the life of the spirit because she invites us at once to open up to the subtlest suggestions of the soul and to integrate them with our lives and duties. As she writes in her exquisite quatrain "Waiting":

> The jeweled cloud sways overhead
> waiting.
> Meanwhile, our cells are turning to air,
> finer and finer arrangements of light.

For many years I thought I would be among only a handful of people who knew who Dorothy "is" and who can derive strength and joy from her. Now in *Marrow of Flame* she will make many new invisible soul-friends, and her profound illumination will go on living, long after she or I are dead, in the deathless Light that all souls live in and somewhere know as their origin.

MARROW OF FLAME

Drowning in god

Those drowned in God want to be more drowned.
 —Rumi

Everything in.
Nothing held back,
 not the bewildered face in the mirror,
 the memory of the first time,
 the quarrel and reconciliation.

This wind will sweep you
 from yourself,
the way clouds absorb an ocean,
the way fire seeks out
 the marrow of flame.

When it is over
you will be less than a bit
 of twisted weed,
smaller than a splinter
 of sea-blackened wood.

You will not miss
your lost possessions
nor even remember their uses.
When someone shows you
your cast items,
 your familiar appendages
 and agendas,
 even your flashing ornaments,
you will look puzzled,
and ask, "What are these?
Their functions or relevance?
I have drunk from a deep well.
What are these sips you offer,
 'just for the taste?'
I'm looking for a world
sky deep in water."

ONE

Tracing of Light
Brushed by the lion's mane

Seekers

Each of us is searching for
a wise man or woman
to lead us,
to present us
a scroll heavy with answers.

Some of us have climbed the mountain,
tracked the glacier's crust,
lain down in snow for days, years,
burning away to essence,
preparing.

Others have clung
to the underside of overhanging rock
until their fingers turned
to stone,
until they were riveted
like lead
to this thin edge of certainty.

And others wander, drifting like mist
through the valleys.

What is it we are seeking?
What will we do if we are brushed
by this lion's mane?

Smoke Clad

Only the stunned and bewildered ever glimpse the throne.
—Rumi

All of us have been stunned enough,
and bewildered enough,
passing again and again over landscape
we could never name,
sun where stars should be,
moon coming forth at noon,
ourselves leaping through exploding
rainbows of flame,
landing, perhaps, at the heart,
the silent core,
hands glowing and empty,
bodies clothed only in ashes and tint.

The Runaway

The Place you are right now
God circled on a map for you.
 —Hafiz

The poet tells you
god has put a circle around you on a map
to locate you in sacred space.
Then why do you keep tunneling
underground,
carving labyrinths for your escape?

Going Over

This poem of Kabir,
the one beginning,
The flute of interior time is played whether we
hear it or not—
How often can we let ourselves
say these words in silence,
without danger of losing something,
our foothold, our grip on the rail,
the tiny thread in our hand connecting us
to something we have forgotten or lost,
until we at last give up and go plunging over
into that waiting, roiling sea?

Don't Make Lists

Every day a new flower rises
from your body's fresh soil.
Don't go around looking
for fallen petals
in a fairy tale, when you've
got the golden plant
right here, now,
shooting forth in light from your eyes,
your awakening crown.

Don't make lists, or explore ancient accounts.
Forget everything you know
and open.

At the Very Moment

No matter what you know,
someone is always wanting
to correct you,
to sell you a bill of goods,
from the shop marked
"authority."
All the "authorities" got
frozen into stone years
ago after the great flood
wiped out original knowledge,
and left behind only these granite shadows.

Reality is always
soft clay,
ever shifting and changing
its shape.

Fire it into form, and
at the very moment
you are hailing it as
final truth
it will break in your hands.

In the Tent

Everyone wants to gaze on
the mystery,
there, in the center
of the tent,
all draped in darkness,
like a writing of ebony
inscribed on night.

The crowd, impatient, shuffles, sighs,
becomes an edge of melting snow.
Only the god-haunted few
remain,
staring into the purple cleft,
waiting.

Why

Something inside me
constantly bleeds towards god.

That's why I keep writing,
slipping messages under the door.

More from the Tao

1.
When some put on robes
and others bow down before them,
it is already lost.

2.
When some speak endlessly,
while others sit wide-mouthed
writing in notebooks,
it is not present.

3.
When groups begin
to look all alike,
and comb their hair the same way *in contrast to the*
and can be found doing identical things *direct way*
at a certain hour,
nothing is happening.

The Task

This is like a lover
who gives no rest,
but demands, and demands, and demands.

Do you think this is a time for pausing,
for lying about under the pine trees,
sampling your lunch pail?

If you are chosen to be the consort,
do not refuse the King.
If you have been outfitted
for a journey to the Himalayas,
do not nibble away your provisions
before you reach the ice.

The Entry

(*homage to Kabir*)

Not from saying names,
or praying to statuary.
Not from holding your breath
till you are blue in the face.
Not from twisting your torso this way, now that,
till you are like a string
striving to become a knot.
Not from reading saints' lives
or fingering a billion beads.

Only this:

The moment *between* the breaths.
The stillness *between* the notes.
A firefly extinguishes itself,
bleeds darkness
before its final flare.

Order of Melchizedek

Know who you are.
Do not debase the name.
Carry it in your heart,
a root flame of love.
Walk through the world in silence.
The moment will come.
The sign will be a soft stirring of wings,
a gold shimmer of air.

Nomads

> *Beyond this flame-desert, other, even wilder deserts.*
> —Rumi

Here, where we have traced
sand circles by day,
danced ourselves to lostness
beneath the night's pale eye,
till we fall in a love trance
on the seething, swimming floor,
you say—other deserts,
more flaming, more wild?
So, then, when we can no longer stand,
we can always make our way
on hands and gold-laced knees,
we can always find a way
to swim through tossing sand.

A Golden Haze or Halo

I know you are there, waiting to find me,
to take me in your heavy jaws,
to gulp me like a morsel
or cough me up like
a briar.

For I am covered in thorns.
No, that's not so.
I am slicked over, oiled,
like something disguised
for a celebration.
I have made myself
an easy prey,
something to be quickly swallowed
and digested
or else spat out in disgust.

You keep calling,
I keep looking the other way.
I beg my responsibilities,
my serious obligations.
You hear none of my
protestations,
they are irrelevant, weightless as air.

You sit back on your great haunches,
swish your tail,
make a warning growl in your throat.
I no longer remember how long
you have been there,
when you came.
Each time I scanned the landscape,
you are always what I saw.
Your mane floats like a golden haze or halo
around your unfathomable face.
Now you are pacing again.

TWO

Night Echoes
An unlit lamp

Gifts

The Divine Lover, says Hafiz,
will smash your windows out
to throw in holy gifts.

Did you realize
that the windows would be
all the openings into your own body,
each pore,
that your very soul
would crumble,
that you would lie awake nights
listening to your bones cry out
like hungry ghosts grieving
their lost worlds.

The Only Rule

Longing is the core of mystery.
Longing itself brings the cure.
The only rule is, Suffer the pain.
　　　　　　　—Rumi

[handwritten: speaks to/of the creative process as well as the spiritual path]

How could this happen again?
To me, of all people,
the one who knows,
who has been through
the gold-tongued flame
so many times
that even the edges of
her shadow
are singed to
a deeper blue.

How could it come about
that I, of all the rest,
the one wandering and lost
for so many lives
of suffering,
must stand upright
for yet another slaying?

How could I not remember?
Why would I venture in
to stroll the avenues
of the deserted city,
forgetting the blade's
delicate thrust,
heedless quiver of love?

Do I not have scars
to prove my foolhardiness?
And now what prize
am I seeking?

More scars,
more sacred wounds?
To savor once again
this secret baptism of pain?

The Picture

In the foreground, something,
 perhaps it is a doorway,
 perhaps a beacon.
 Or else
 a bridge, one arch
 in shadows,
 milk-blue water flashing,
 and the air,
 saturated,
 shimmering with
 bold intensity,
 a yearning toward—
 impulse of creation?
 (how the levels fuse)

 all lifting toward
 that bloom of faces
 peering from the
 overhanging cloud of gold,
 illuminated heavenly host,
 emergent glory . . .

 or is it the assembled souls
 of the vanquished,
 those who stumbled on rock,
 or were crushed,
 whose wings were singed
 to thinning bronze,
 these so still watchers,
 now waiting,
 waiting to see what the water will bear.

An Unlit Lamp

You're doing it again.

You say that no one
understands you, that you've been working
in darkness
for generations,
like a mole traveling
in a circle under a basement.

What of those
who have spurred you on,
been lavish in their praise,
offering you love-packets
of hard honey and almond.

But what about before,
you say,
all those years of twilight
and stillness,
feeling your way forward
through the corridors
with an unlit lamp.

Pain

We bury our pain in a secret crypt,
stealing out at night to worship or pray.

We insist our pain is nameless,
and therefore does not exist.

We hide our pain behind the crockery
on a high shelf,
convinced that when we lift it down
it will be less vibrant,
muted by dust and silken webs.

We put it in with the silver
which we use only on Rare Occasions,
removing it with the flatware now and again,
to polish and make inventory.

We wear our pain inside
a small locket around our neck.
We carry it as a stone hidden in our shoe,
or else as a thorn riding our flank.

We fasten a red ribbon around our throat,
so that we do not speak or whisper.

The Men Who Denied the Goddess

How she arrived
in her shimmer of bright silk.
Her rawness, her nakedness,
her beauty.
How her breath swept over them,
seeping into their pores
like incense,
like smoke.
How they muttered and groaned,
how they sobbed into their hands,
as they turned
against the shining air.

Aztecs

We have all had our hearts torn
from us,
one way or another.

The poets offer a brief consolation
every now and again.
We follow them into that other world,
their soft nuances of feeling,
their subtle manipulations of tone.

We fall into a forgetfulness,
a swoon of word longing,
how dear the imaged moment,
how precious the projected scene,
but then we remember
the block on fire,
the city blazing around us,
the corpse waiting in the plaza
beneath the unyielding sun.

The Birthmark

Is god only
a drop of honey on the tongue?

A night owl who keeps calling
to the darkness he wants for lover?

Is your soul's wound
just a remembrance of where
the spirit kissed you
as you were being born?

From The Language of Stones

1.
The Stone Who Fell from the Sky

I came here from a far place.
There, where I was,
it was always daylight—
daylight and a blaze of movement,
atoms passing in clouds
through one another,
tangled mist of amber and amethyst,
who can separate
what is the same?

Then I felt a strange pull
drawing me,
and I went falling, falling,
sparks tapered in density,
everything enclosed within.
I settled here, this featureless place.
Now, when they look at me,
they only see
a heaviness steeped in silence,
a swollen unmoving grief.

2.

The Stone Who Knew Everything

I've got it here, inside,
all the stories, fables, myths,
tales of longing and regret,
brides kicked out on the wedding night,
mothers roving the hills
seeking the lost child,
the lover afraid to ask.

Everything, all of it, here,
locked up, engraved
on my hidden cells,
a single drop of this
bitter brew
would unmake a fragile soul.

But I don't share.
I am too ancient and venerable.
As long as I stay here,
still,
half-frozen in earth,
they will come with their
burdens of grief, their pleas,
their catalogue of sorrows.
I will not speak.
They will take my silence
for wisdom.

First, You Have It

First you have it.
You look around, and say,
That wasn't so bad.
In fact, practically anyone
could do this,
given a little time
and the right circumstances.

Then one morning you wake up
and find it's not there.
No note, just gone.
You look all over,
upstairs, behind the furnace in the basement,
under the pillows on the old sofa.
Nothing. Nobody.
Your house an empty cave.

Was it all a dream , you say,
a longing for return to mother-source?
You decide to draw a picture
for consolation
but how can you?
You never saw a face.

He Sees

> *He sees that he sees that god sees beauty.*
> Dream Voice

God sees beauty,
sky-silk unreeled, shaken to a fineness,
a glowing in the afternoon bloom,
burnished sun-shadow
hovering over
the stammering quills,
bolts of copper and cream, translucent,
echoing through the boughs.

And yet
we must all have
a question for god.
We each must ask,
like Blake,
who loosed that beast
which stalks the savannah's green
and fastens his burning gaze
on the gazelle's expectant throat.

Maya

Again and again we make our world,
moment by moment
it drifts away, perpetually dissolving
in the descending light.

Seers

Suddenly it springs forth,
the slanted shadow over the nose,
the observing eyes,
lilac lips set,
throat full and resolute,
cast, features,
prominences and declivities,
mirror image of that which is.

And then it folds back
and becomes
something no longer clear:
eyes peering from wrinkled flesh of bark,
crumbling ancient mask,
the space where a crow once hunched and waited.

In This Middle Realm

Flawlessness of
ultimate being,
objects swirling in
chalice of perfection.
The Absolutes.

But in this middle realm,
things loosen and slide
and have no beginning,
everything spread out
moment to moment,
display of inadequacies and betrayals.
Was it ourselves
or the other who failed?
How irrelevant now.
Only the final forgiveness
will take us to light.

What The Prophets Said

They said that the planet would vibrate
at an ever increasing rate.
They said there would be more heat,
more shaking, everywhere.
That many mountains and beings would be torn
open,
and the spilling oceans would devour the land.
That time itself would accelerate,
until it arrived at absolute zero,
conjunction then of no time, no space,
merely the terror of the real.

What Is Happening

Moment to moment
we ask, what is happening?
The sound of shattering everywhere,
is it the world, fragmenting at last,
or our own hearts cracking,
the final break-up of ice?

Meditation in Midwinter

1.

Each day I become less
of a presence,
more of an abstraction.
Soon I will be
nothing but air,
a space reciting verses.

2.

Always the heart is heavy,
drags down,
anchor pulling through
mud and rock.

3.

Why do the Buddhists labor
to convince us of the
transient nature of things?
Each day we grasp
for anything, a fragment, a leaf,
which will stay,
not dissolve like scent in our hands.

4.

Our heart says
not just that we will
not always be here,
but questions whether
we were ever here at all.
Dislocations and scattered memory.
What else remains?

5.

The present is a mottled clown,
the past a fading mural
on a decaying wall.
The future beckons, a violin
playing silent scales at dusk.

The Dying Round the Holy

I am not forgiven,
nor will be:
today, the rain softened a little,
gentler strokes soothing earth's bones,
naked mouth comforting.

The rivulets,
unleashed,
are rioting forth,
raucously claiming
their lost selves,
thrashing ahead
toward that majestic roar,
that mother river celebration of return.

I linger,
cling to these drenched petals,
amethyst stains soaking my hand.
I clutch this ribboned stone,
call forth, inhale its dark energies.
I drink odor of pine,
sense roots tapping my feet.
When will I begin to melt,
to spill
toward vastness?

THREE

A Stirring of Wings
The many doors

The Woman Who Lived in a Cave

It was cold there.
At night
the stars came out
and looked down on me,
my quiet austerity,
my meek accommodations,
with a cool camaraderie,
ice acknowledging ice.

My meditations were my passion,
the gods in their attributes,
their colors and forms.
Each had its fixed aspects,
demanding perfect recall.
I labored, hour after hour,
year melting into year.
To err would risk
sacrilege, shame before heaven.
But the figures grew always sharper,
my discernment more refined
till the images breathed with life
and I and they were one.

For comfort, I had my small
butter lamp and the candle,
but of course I saved these for
only the essential.
Mostly the dying sun
signaled the end
of my day.
Again, I rose
when the light
flooded the valley below
with filtered honey,
touched the tip
of my sleeping box
with its prodding finger.

I had nowhere
to lie down properly.
The box was not
long enough to lie in,
nor wide enough to stretch.
I did not mind.
My aim was not to be
comfortable,
but to be still,
and enter the silence.

The only voices I heard
were the crying of those
mountain birds,
the wind cracking against
the boulders,
the rain slashing at
the cliff.

But this was what I had
dreamed of,
the life I had come to live.
This was the person I had chosen to be.
How could I flee my dharma?
Besides, I had done it
so many times before
it was easy,
a familiar pattern,
like a garment one folds
and unfolds,
moonlight, darkness.

Tenzin Palmo, who was born in East London, became one of the first Westerners to be ordained as a Tibetan Buddhist nun (1964). For twelve years, she lived in a cave in the Himalayas, seeking Full Awakening. See *Cave in the Snow* by Vicki Mackenzie (Bloomsbury Publishing, 1998).

The Hermit Monk

Because I was nothing
within my coarse shirt
I found everything without.

Snail path stirring,
blood slash of cardinal rising,
water-stained rocks with holy faces—
all entered me.

My flesh became a translucent veil,
admitting all freshness.
My bones were wavering pillars
set in a house of light.

When they found me sunk in my leafbed,
my hair was moss
feathering the tree roots,
my hand a shellcup
holding water,
and flowers burnt in my eyes.

Theodora

She went through
the many stages:
Hippodrome waif
scrabbling for fish or castoff figs
in the garbage bins,
dancing for coins
to amuse the waiting crowd.

Finally, she did the thing
she had to do:
her body was a coin,
passed from hand to hand,
her voice a lute
to draw the seekers near.

Later, Alexandria, and Timothy,
man of burning tongue.
What word
was planted in her breast,
what purpose settled
in her heart?

When Justinian came
she was waiting.
Together, they
transformed a world.

Empress Theodora (ca. 500-548) began her life as a child actress in the Hippodrome in
Constantinople, a profession then synonymous with prostitute. As an adult, she continued
her scandalous career until she came under the influence of Timothy III, a patriarch of
the radical sect, the monophysites. She subsequently wed the Emperor Justinian, who is
credited with converting much of the western world to Christianity. She was a major
intellectual and political force during his reign.

Bodhidharma Returning

(Around 527 A. D., Bodhidharma carried the message of Buddhism from India into China, where it developed as Ch'an [known later as Zen in Japan.] The speaker, in a curious dream, saw herself as a highly diminished reincarnation of the ancient patriarch.)

I once carried a world on my back
into a new land.
The emperor, affronted,
challenged me,
but I turned my face away,
and did not respond
for many years.
At last he acknowledged my presence,
and the people, seeing,
became my flock.

My fame and wisdom spread
till everyone knew my name,
the strange practice I brought with me
now accepted as a familiar household rite.
My work finished, I withdrew
into the back pages of history,
someone who once did something.

After I died I waited several centuries,
then felt the world trembling for my return.
I came down,
shrunken to a seed
cast haphazardly on unfamiliar soil.
Somehow my intensity had waned,
so that there was never a real blossoming,
a passionate avowal,
only darkness, a constant pressing
against unyielding earth,
a soft battering upward
through the tangled roots,
and silence stretching,
stretching,
toward the thin filament
of sun.

The Lovers

If the gods are ourselves, extended,
then we met in transcendent space.

Magnets swung round at our approach:
force fields reversing in pulses.

Our kiss sent clouds
of passionate angels
floating through one another.

Our cries of love
were instantly translated
to sacred scrolls
rippling down the side of heaven.

Our gestures were repeated endlessly
in myriad expanding cosmic mirrors.

From afar, this landscape glistened,
like crystal turning to light.

Familiar Story

Everyone speaks in affirmations
at a certain moment,
and, in the heat and pitch of it all,
they mean well.
They are but stranded in the nets of love,
familiar story.

Oh, dear ones, have you looked
at the roses of summer,
how their billowing cheeks pale,
then loosen and curl in the relentless
suns of autumn,
how the chill winds lift them
out of their cloistering shells,
how they surrender, at last,
to the dust scattering below.

Persephone

You may think this is a story
about a woman going down to a man,
her lover, sinking like smoke
into his flesh,
dissolving
like mist into the shrubbery.

I tell you, her descent
was not to alien ground,
but rather a spiral through herself,
mysteries yielding at every turn.

Oh, he was useful to her,
offering as he did,
instruction in her own
forgotten rites,
leading her, as he could,
to rediscoveries
of what she had always known.

He thought himself a mentor.
Actually, for her he was
like someone figuring
in a dream,
someone occasional
and indistinct,
whose significance
was never clear.

And when, called back,
summoned by Lady Mother,
she rose, clutching in her hand something,
a seed, a flower,
she flew upward
like a figure from Chagall,
to where that *woman* waited,
mirror image coming clear,
already forgetting what it was
she left abandoned all below.

Merope's Prayer to Isis

My call is to Isis,
she of the shining spirit.

Isis, come among us,
we who now enter the timeless
together.

Oh, Isis,
let me be your creature,
to serve you.

Let me sleep
beneath your breast,
where energy flows.

Isis, let your voice
come into my throat,
your presence
unwind the dance
in its slow spiral.

The Woman Who Loved the Goddess

At the end
nothing could save her.
Names murmured by leaves
stirred in darkness,
sight of the stony breasts,
earth fold under tree rootæ
anything could set her off.

And then she would go raging,
groping beneath the shallow waves
for a body of seaweed.
Or scratching among the earth seedæ
wheat, fallen corn,
seeking the buried corpse
sown with life.

But nothing came of it.
The villagers drew close,
muttered together in dark circles,
and at last drove her out.

She seemed hardly to notice
that she was leaving.
One place was much like another
to her now.
She went along the windy roads
softly crooning
ancient songs with no meaning,
to the band of jeering boys
who trailed her, half-afraid.

The Sibyl

Everything on this journey
is fortuitous, unplanned.

What you call my madness
is the food of my life.

The silvered mesh
between the worlds
doesn't really exist for me.
I never go over.
I am there already.
It is easy, like parting a sheen of water,
an animal floating in arcs of color.

How familiar they are,
these inner musics,
these currents of desire.

It is the other part that is difficult.
The coming back.
The not being able to tell.

The Witch

I was always a nice girl
with a few bad habits.
I whistled a lot
out gathering eggs.
When my brothers hand-wrestled
I insisted on winning.
The villagers said
I walked like a boy.

My father used to eye me from afar,
and hold private conversations
in the corner with mother.

When the other girls married
I took no notice,
though I threw rice at the churchdoor
along with the rest.
Whatever I was seeking
it wasn't this:
a screaming cradle
and a man with soot for fingers.

Once I went to a gathering
in the heart of the forest.
Where shadows make shadows
I learned my true name.

Since then I have lived here
at the edge of the woods
with my tabby and my charms,
my thatch needing repair.
My potions are famous
all over these parts.
When people come seeking
from near and from far,
they ask what goes in.

I mutter: "Roots and berries.
Berries and roots."
How can I tell them
it is themselves they taste?

The Woman Who Fed God

(In 1330 B. C. E., a memorial was erected in Egypt to Maya, Tutankhamen's wet nurse, who "fed the body of a god.")

It sounds so simple.
This giving forth,
the allowing.
Flow of sacred essence
into the wanting mouth.

I did not ask for this honor.
It was bestowed on me,
an inevitable,
the way a seed is planted in an earth
which was not consulted,
or planets keep crossing
a space, disturbing its dream of innocence.

Each morning I had to prepare myself.
The bathing in the sanctified water.
The purified oils smoothed over the skin.
The temple cloudy with prayers and incense.
Could I satisfy his need?
Some days he would not be filled,
greedy for all I had;
other times he turned his head away, complaining.

The onlookers kept speaking
of Isis and Horus, the divine elixir,
my exalted role.
But I thought only of the other child
taken so soon. Where? Into whose arms?
And of her scent, which I did not know.

The Taskmaster

You said, "Write verses,"
and I did.
Word ribbons flew off my tongue,
streamers of feeling.
You said, "Be still."
I leapt into a well of silence,
stifling the cry from the throat.
Now I huddle on my little ledge,
not knowing if I am the stone which holds me,
or the darkness seeping into my mouth.

The Granary

I know,
you want to speak,
you hovering overhead,
waiting.

All right, I say,
let the words come.
Let them flow
like grain from the granary bin,
streaming in torrents and waves,
rushing to return
their gold to the sun.

The End of Komachi

(Komachi was a renowned court poet of ancient China, who, according to legend, "ended her life . . .an ancient half-mad hag living outside the city walls, though still writing poetry. . .")

1.
Court Romance

Her unnamed lover.
The morning poem.
Standing outside the door, waiting.

2.
Night Echoes

Plum blossoms, mottled silver.
The night a burnished reflection.
Moon woman blushing.

3.
Offering Incense at the Temple Door

Fragrance of pinecone and spice.
Smoke threading the letters of a certain name.
Will the gods attend?

4.
Crane

Old skin-and-bones in clay hut.
Hoarse whisper of poems.
Crane dancing in moonlight.

The Old Woman's Night Song

Now I am old
my bones go rattling through me.

Ai-ee, ai-ee.

These are the bones
that carried me up
to the berry-picking ground in spring.
My bucket was full.

Ai-ee, ai-ee.

These are the bones
that danced
to the spirit drums,
as the ghost people watched from the fire.

Ai-ee, ai-ee.

These are the bones
that parted for my child,
little raven eye seeking
its lost brothers and sisters.

Ai-ee, ai-ee.

But now my bones
go rattling through me
as I dance,
blueblack shadow of owl wing
circling,
under the bone-white moon.

After Death, Like Flows to Like

(for Denise Levertov)

I often think of them
streaming together
to form one being,
those who kept stroking
reality alive with language,
who did not separate
word from thing.

Carolan with his harp,
stricken Dante, flaming rose,
Li-Po and his jug,
unsteady moon lifting
through shadow,
everywhere a constant singing,
a music beyond our hearing.

Once we called them muses.
Sometimes we catch glimpses of them
in blossoming summer skies,
or say their names
when we begin.

Her Body Revealed at Last

Nature is Him, my friend, One Dance, one Body.
—Rumi

1.
Ice Plants

I can say nothing
of the lost kingdoms—
Atlantis, Shambhala—
the mystic crossing lines.
But here,
these trembling spears of sun,
swimming mirrors of russet and green,
transparent fish blades thrusting,
dancing upwards in this net of light,
the ocean's luminous catch,
ready for tomorrow's market,
ready to be tasted,
to be swallowed whole.

2.
Rainbows

As if the storm were not enough,
then there were rainbows.
Rainbows, not made of sky,
but fashioned from the waves' own sheen,
hued ribbons unfurling,
lilac, amber, blue,
flinging themselves across the line of spray
in arcs that streamed along the spume
like world horizons blown to color,
like energies of water sprites
released in shooting circling bands,
in some celebration we witnessed silently,
not knowing then

what it was we were looking on,
or if we were meant to see.

3.
Before the Pleated Wings of Summer

Nothing is wild here,
but they push through
in ways to deceive
all but the keenest eye.
As if seed randomly sown
ascended in throats
of color,
great swatches of iris
singing darkly
along with the
spills of poppy,
dust of saffron and gold,
white daisy grazing the beds,
I think she is leaping forth again
in her gauzy muslin,
rehearsing her coy fandango,
her spriggy green gavot.

Scars of Rapture
A hidden sun

The Seraphim in Winter

It was winter.
They cared nothing.
They stood there
in their bold assertions,
quivering cones of flame
banded yellow,
orange, and red.
They said, we are here.
We are the presences,
observe what happens
when the irreducibles bleed.

And each time a humming bird
appeared,
vanishing circle of light,
its iridescent thrust
not a violation,
but a swift pleasure,
a mating over and over
of what is rooted,
what pauses and flees.

Scars of Rapture

Shams, I have done everything I know
so this would not happen.

You came into my life
like a wing of fire,
possessing and possessed
by something not seen.

When you first spoke
my books turned to clay,
and my throat closed
around a lost syllable.

Your eyes burned over me,
leaving scars of rapture,
my spirit became a field
swept clean by flame.

Can you think how it was
that morning I woke first,
and found you,
an unbound mystery
by my side.

Or the day we did not eat,
but drank from one another's light
till we were ribboned by dusk.

The air here holds only emptiness,
a little dust stirring.
I think there will be wind tonight,
and the camels will cry out
in their sleep.

When Rumi's beloved teacher Shams mysteriously disappeared, Rumi was inconsolable.
He never fully recovered from the loss.

The Moment

> "We Must Die Because We Have Known Them"
> *(Title of poem by Rilke, taken from the*
> *sayings of Ptah-hotep, ms. from 2,000 B.C.E.)*

And not once,
but many times over,
again and again,
how we disappeared
into that deep well
of darkness, shuddering beneath that load of silence,
clinging to our narrow ledge.

Yet the darkness, sometimes,
unfolded as light.
Our atoms dissolved in it,
each separate molecule opening
into a radiant disk of feeling.

How still we became,
witness and thing seen,
spectacle and observer,
each point admitting an untrammeled flood.

Shambhala

This is a place that has no place,
a city of light that has no sun.
Travelers seek it in drifts of desert,
tall mountains hung with snow,
who goes there cannot tell the way.

Their Weighted Muses

How can I believe in
something,
just because it happened?

This outward agitation,
these shifting scenes and patterns.

All I know
is the music within,
blood pulse,
cry of atoms
along the template of bone.

Even the names of flowers
and trees
are always escaping me.

Sometimes I envy them,
their tangibles,
their things of substance and form,
their weighted muses
hung with segments of the real.

A Sense of Infinite Passage

I have always been struck
by essentials:
not the corrugated surfaces
of the mountains seen from above,
or the amber jewel flickering
at the tip of the wing,
but the sense of infinite passage,
the going through and into,
the sequence of moments
peeling off the immediate
like a skin,
layers of conclusions and beginnings,
the endless field of cobalt
which lies ahead.

A Single Tree

Not so much time itself
as the changes,
the constant shifting
and metamorphosing
of things into
their opposites,
or, more likely, diminished versions
of themselves.

The cat, grown old,
stumbles about the room,
and doesn't remember the year
she leapt from sill to sill
taking the lace curtains
down as she went.

And the tree,
a blackened scar,
opening its side to weather
minus its most stately branch,
long since taken off
by wind, or lightning,
or something obsessed
with symmetry—
does it recall the winter it stood
alone, unyielding,
against the hammering gale?
Or its abundant leafiness in spring,
its green proclamation
of all that continues
unabated in this world.

The Yogi Inside

What she wants
is not words nor fastenings,
nor doctrine spilling over her
like salt,
nor precincts set off by markers:
This is sacred space.

Wherever she steps is holy ground.
Moving, she traces streams of light
with her hands, her body.
When she listens,
she becomes a spreading tree of silence
that knows only itself.

Waiting

The jeweled cloud sways overhead,
waiting.
Meanwhile, our cells are turning to air,
finer and finer arrangements of light.

Teresa's Enigma

How can I explain this?
Yesterday, pain cleaving a path
over shoulder and arm,
eyes stunned by arrows of light,
back a maze of burning rivers.

Today, Vivaldi, *Stabat Mater*,
a subtle lifting in the heart,
wrists floating in rapture,
in my mouth the taste of honey and flame.

Like the speaker in the poem, St. Teresa of Avila suffered periods of intense pain and suffering as well as transcendent rapture during her transformation. Such extreme oscillations between pleasure and pain are often a characteristic of those undergoing awakening of the Kundalini energies, a highly charged spiritual phenomenon becoming more and more frequent in today's world.

Locating the Invisible

I have nothing to go on,
not even a name.
If asked "what tradition?"
I can only look away.

Is it enough,
this touching within,
this constant infusion of "the other"?

Something Else

Whatever it is hangs over us,
wants us to keep on gliding forward,
as if a compass nestled in the heart,
as if a hidden magnet were always calling to
the bits of iron which swim in the blood,
or a boat was being drawn ahead
by a canal-man, with his steady line and
unwavering eye,
not asking why, just doing it,
even on the days we awaken
amidst the ruins of the spirit,
and have nothing to offer,
except a longing for the smell of hyacinths
and something else we can't fully recall.

Whoever Went In

Whoever went in
naked to the core.
Whoever cast aside
all the armor,
all the fastenings.
Who could breathe air thin as flame.
Drink water pressed
from rose petals
or violets.

Whoever stayed in that
darkness so dark
it became a circle of seeing.

Who could hear
the silent flute note
of the stilled wind,
hold rock turning to light.

The Abundance of Brightness

God is not unknown on account of obscurity
but on account of the abundance of brightness.
—St. Thomas Aquinas

1.
Dante Mounting to the Rose of Heaven

Not one of us
could breathe this air,
face this naked radiance
unscathed.
Here music turns to light,
a tone so sweet
that we, dulled by
our familiar calliope,
mistake its sound for silence.

Dante, mounting the tiers of
trembling flame,
found light. Light everywhere.
Circles, wheels,
light on light,
a dance of invisibles.
The flames pulsating, as if
measuring the breath of heaven.
At the last, he falls forward,
caught in widening rings
of implacable bright.

2.

At Eleusis

Even at Eleusis,
after the long journey,
the sea-bath among the sacred waves,
the accounts of the grieving mother
and her vanished child,
at the end
the shouts rang out
like birth-cries in the throats
of the startled pilgrims, blinded
by the flare of torches sweeping
from frames of darkness.
Then silence. Then they saw.

3.

A Celebration

And then quiet.
Someone who whispers:
now we are free.

Which was, almost,
true,
but only in the way
a bird,
leaving a limb,
goes freely into
a different realm,
an atmosphere
more pure,
more transparent,
but that, too,
maintaining its fixities.

4.

The Clinging

> *[for those who] have beheld the Tao . . . gems sparkle on dusty roads; puddles appear as pools of lapis lazuli; tough weeds acquire fragile beauty . . .*
>
> —John Blofield

The I Ching calls it clinging, fire:
"Fire has no definite form,"
it says,
"but clings to the burning object
and thus is bright."

On this Grace

I did nothing to deserve this.
I came here, lived my life,
entered in as best I could.

At first I wandered through
other people's stories,
a child with a solitary book,
a child dreaming
by the fire.

Then I tried love.
Those spicy apples
were sweet in my mouth.
Their fragrance filled the air.
I was a pushover,
sending my heart along with
the gift of roses.
Soon I learned
how to fall from
a great height.
Soon I felt how it was
to be decomposed
back to earth,
to dry seed.

It was only when I felt
I had had enough of this
that something opened inside.
I could not name it.
I could find no one to
direct me along its course.
There was only this something,
insistent pressure of claiming
and being claimed.
Now it is like a flower
that will not be thwarted,

that keeps unfolding,
relentless,
petal by petal,
a hidden sun.

When We Stumble and Find It

We all have our favorite themes,
the ones we say over and over
in a thousand different tongues.

Mine is the moment which
changed my life
forever.
Not the one I planned for
or expected, but the one which simply
happened.
It could have been a
revelation
speaking from a cloud of fire.
It could have been
a rare accomplishment, election
descending like a dove after
so many years.

It was none of these.
Merely a moment,
the one I keep returning to,
feeling along the wall for the
hidden latch
which will spring open
and reveal the undefined.

Marrow of Flame

The unknown angel

The Creation

First it was a fire
shaken out of nowhere,
sheets of bluewhite, flashing
across expansions of light years,
across eons,
across everything,
time itself
swelling inside
that furious belly,
rounding,
splitting,
shaping itself toward another order,
a mirrored universe,
turning and cooling,
at last settling and shrinking,
becoming this place,
this home,
this where we are.

The Unknown Angel

1.

On the Invisible One Who Comes

What is it
keeps coming,
morning after morning,
rousing me to a question
and a longing?
What is this airy resonance,
like a quickening spirit gong?

Now I know what Psyche faced,
her fatal candle splash.
Now I understand the difficulty
of mating with invisibles.

2.
Confronting the Angel

Who is this
that's always wanting to be me,
coming in unannounced
like a guest arriving
unexpectedly,
or a stray showing up
at the door at dinner time?

I'm not sure when I issued
this invitation,
or where it was addressed.

Or, for that matter,
how long he's been hanging around,
or even how all this got started,

Sometimes I think we
try on each other's clothes
just to see how it is,
to know how the other half lives.

Sometimes we speak in an altered voice,
mimicking the other's tone,
or else forget all about borders,
and rush together as some utterly new,
not yet discovered thing.

Sometimes I think
this is what I
have been wanting
in all my lifetimes,
again and again,
forgetting all else
while the worlds turned over.

3.

The Other

I can stand it
that you arrive with no name,
come in without face or form .

I can bear the reality
of pressure without weight,
movement without presence.

But how do you choose your time
to appear,
the moment to go?
What is it you keep almost saying?
And where are you
when you are not here,
with me?

4.

The Unknown Angel

Sometimes I think you are
all of our past lives
jumbled together,
all the lovers we wanted
who went away,
all the nights
we lay together with the chosen one
until the ending,
everything that disappeared,
whirled backwards
into *anima mundi*,
the place that takes in
the world's many discards
after they've finished here.

Or maybe you are some lost poet,
fragmented and searching,
dreaming among the hungry ghosts.
Perhaps our souls once joined together,
or else they came
from the same reality.
Hence, why I loved you,
why you loved me
(despite your vastness).
Why we always struggle,
each of us,
to cross the boundaries
into the other's realm:
carried over by masks,
by music,
a subtle shifting
of the dancer's pose.

The God Mother

1.

The Nurturer

She is a breast
hanging down from the sky:
Open your mouth
and feel the
thin sweet milk
of the sun
roll down your throat.

2.

Our Lady of the Plants and Animals

Everything blooms
from her body:
her arms are long-stemmed lilies,
her ears the shells
from which the anemones spring,
purple hyacinths spiral
between her thighs.

Small creatures
unfold from her
sides and belly:
Rabbit, ground squirrel, pig,
the cautious field mouse,
and the cat
who will eat it,
the fish
and the larger fish
swimming forth together.
From her throat
five thrushes
are leaving
in eddies of sound.

3.
Kali, Goddess of Death

She wears her corded
necklace of skulls
and her arms hold
many strong implements,
one is silver
dipped in red,
we have forgotten its name but
we know its meaning:
one sweep
and everything
vanishes,
we, our fleshly forms
and intentions,
our notions of things,
dissolving,
one swift stroke
and the pattern of millennia is reversed,
atoms shattered back
to nothingness,
worlds tumbling back
to darkness,
to before.

The Woman Who Loved the God

> *The soul is kissed by God*
> *in its innermost regions.*
> —Hildegard of Bingen

They are a curious lot,
their odd names,
their strangely lit faces.

Some are clearly wanton,
arranging their naked limbs
at angles,
like borders of a flowery
invitation.

Some seem a bit stunned,
as if the presence still
hovers near.

And some are more pious
than is fitting,
hunched penguins
mumbling their beads,
kneading time
into timelessness
in heavy fists.

No matter.
When it finally came
it swept through
their body's arc
like a wave of violet light
seeking a center,
carrying them into
the second realm,
while they moaned,
and wondered

how this could happen,
to awaken
after so much forgetfulness.

What was it that took them,
virginal for so long,
to this other place,
now brides opened,
their wombs swelling with rapture,
belly rising,
as if to give birth,
or cling yet more closely
to the lover,
his body of moist cloud.

The Woman Who Slept with Shiva

I called him down,
and when he came,
I opened my arms,
as if to a lost husband, or child.

I thought I would turn to ash
in that brilliant flame,
my body, lustrous
as a crystal,
surrendering its defining atoms of gold,
its threads of memory, even,
to that blinding dance.

Everything dissolved
into a wave of feeling
till nothing was left
but the essential light.

Then I came back.
I slipped away
to the scullery,
and my bed at the top of
the attic stairs,
where I keep my amulet,
and my bracelet of stone.

At first I stayed silent,
thinking of what it might mean.
Now I am telling my story,
but no one wishes to hear.
They say they must tend to the weaving,
the harvest ready to come in.
They worry about sons
who complain of the brides they have chosen,
about daughters who scorch the rice,
and forget to put salt in the soup.

They think that the heat has gotten to me,
recall that my mother's father
was always a bit strange.
I think I have been
on an improbable adventure;
at night I dream of a face
I can't quite see,
although I almost glimpse it, at times,
in the pitcher I carry
from the stream at morning,
in the violet clouds
that gather at dusk.

God's Mistress

The other bears
his ring and name.

I lurk in doorways,
clothed in shadow,
waiting for a touch
so intense
I no longer care
what they call me,
or whisper about in the kitchens.

I am the wanton who keeps close company
with what the fathers denounce
and the many shun.
When god comes calling on
his whore,
the sidewalks empty,
and all curtains close.

The Secret

I carry it around
like a flower,
or a flame
concealed under a dark canister,
its glass so thick
no light can pierce
its black skin.

Sometimes I think
I am no better
than some Caliban
raving in his cave,
conjuring visions,
or an ordinary housewife,
who plays harlot
by night.

Sometimes I think I
grow tired of my burden,
want to set it down:
Let someone else bear this cargo of love.

The Gopi Turned Solemn

Krishna is at the forest edge,
waiting.
He wants, as always,
to awaken your throat with kisses,
seize your heart
with his warm breath.
He wishes to favor you,
allowing your gaze
on his sleek shoulders,
to sweep you across the greenribbed floor.

You, of late, have begun
to turn sober,
to reflect on this relationship.
You want stillness, reverent hands,
an attitude of silence.
You say, "The god arrives
only when we are prepared
to witness from our knees.
None but the clarified self can serve as
the vessel of pure being."

Krishna grows restive,
and taps his foot,
circles his eyes.
If you do not come soon,
he will strike poses,
begin to meddle with his flute.
He may begin the slow dance alone,
his body radiant with a spreading inner glow,
his eyes closing
for another deep eternity.

Still Life

> *The rose that no longer blooms in the garden,*
> *blooms inside her whole body, among the veins*
> *and organs and the skeleton.*
> —Linda Gregg

A hidden blossoming.
Petals flaming beneath the skin.
And a softness pressing,
as delicate as the mouth
of a blind lover.

Each movement,
each quiet gesture
awakens
a rosary in the blood.
Was it desire
which brought her to this moment,
this arrival at source,
or was it merely a need
to be still, to be richly fed
from this fountain
of dark silence.

A Hollow Throat

(for Helen)

Jalalludin, what have you done to me?
I have given you everything,
but nothing has prepared me
for this.
First, you took my jewels,
my jade ankle bracelets,
my sapphire bands,
leaving behind only a tracing of light
to mark where they had been.
Then my veils dropped, one by one,
in a sweep of silk.
How could I protect this
nothingness I had become,
this crystal abyss.

Before, when you came you wore
a vague plume or turban
making you seem real,
a being more like me,
or else, invisible, you
opened the hidden passages
by silence or breath,
or a movement like flowers
swaying under water;
even then the secret bliss waves
were partly mine,
and I knew who I was.

Now, everything has dissolved to music,
a single note from a struck Tibetan bowl,
like a hollow throat gathering the world
into itself.
Even this I could have borne.
But there was no instrument or bell,
only a single pure tone rising through

this woman before me,
universe beginning,
lost primordial hum,
and I— as no one— was entered, sounded,
as a current moved through my body
like god.

A Thousand Ways

The Beloved knows a thousand ways
to enter your body.

When you were young,
she sent you a lover of flesh
who stood near
to awaken your nature.

Now god is your unseen paramour
arriving without notice
on unexpected occasions.
To discover her,
turn gently, and follow your breath
to the center of your being.

More Songs from Lalla

Dance, Lalla, with nothing on but air.

1.

The Prankster

Let the breath come in,
and if a god, too,
make this her subtle path,
do not deny her
entry.
He wishes to build transparent monuments
in your heart,
chambers whose quiet bells will resonate
into your farthest reaches,
your soles, your lids,
your elbows, even.

For the god does not disdain
even the humblest part,
the clumsiest joining.
This is his sly jest,
his coy affirmation
of you as oneness.

Do not fear the god.
As the wind wafts through light,
she wafts through you—
Ruach, Prana, Chi —
lifting bone, cell, and tissue
into that other world.

Even in this one,
trees bend to her
in their slow spirals.
Dolphins breathe her.
Herons glide to her fluid rhythms.
Do not fear the god.

She is yourself, returning.

2.

The Follower

Shiva is the god who dances,
and we, in turn,
with halting steps
must follow him.

How can a human bear this,
this streaming rapture
through the blood?

Nothing has prepared us, ever,
to receive
such blessings
at throat and ankle.

Bewildered, we can
only turn,
and turn again,
releasing our dancer's slow breath.
Forgetting all that is not this:
mother or father,
child clamoring in the street,
the cries of birds, even.

Don't Turn Away

Don't turn away.
I know, I am no longer the young dancer.
I sit quietly, hands folded, a stiff back.
But even now, break the channels open.
Let it come in,
that something which tells me who you are.
I want to be bathed in it,
a hundred rose gardens opening at once.
Even if it is only
a quiver of feeling,
let it happen.
Tell me you are there.

Almost Against My Will

Once more I was
not prepared
Once more it came on me
suddenly,
like an ice storm in June,
a flood crashing over
the parched desert floor
at summer's end.

And there I was,
captive once again
of these feelings insubstantial
as thoughts
as images

familiar music of silence
echoing through
my body's deepening canyons.

The Token

They call it the Formless Absolute.
I call it the one who is near.
In order to describe it,
I can say nothing.
How can mere
syllables capture
that which has no name,
is never seen,
leaves only a small foot mark when it goes.

The God's Abode

Some say the god lies coiled
at the base
of the slender tree,
serpent waiting to
raise his head.

Others seek
rapture in the belly,
hands curving over navel.

Still others
would find a quiet opening
into heart or forehead,
imploring gift of compassion,
jewel of knowing.

The god is
all around us,
and in us.

As light pours through water,
she enters us.

We are her translucent vessel,
container and contained.

The Gods Unchosen Neither Sulk Nor Grieve

I think they have been watching us
all along, those unseen realities,
swarming like locusts or butterflies
around our griefs, our elations,
vying to see who will be chosen,
which we will elect
to come forward,
to be seen,
carried under our arms
to the hilltop, set up for all to view,
to be worshipped and confirmed,
noticed at last.

The others, meanwhile,
don't give up hope.
They neither sulk nor grieve;
they know their turn is coming.
This world is needy,
hungers for all the gods it can get,
inhales them like wafers, like breath.
The gods are useful,
holding us in their transparent hands,
even the ones without names
or statues,
those who have breasts,
and those who look like mountains
or hanging mountain lakes,
aspen fired in gold.

In The Forest

was a path
which led on,
and on as if an access
to a deeper realm—
a place where peripherals,
the eddies at the edge of things,
were all forgotten,
and I entered
a silence of green,
became a soundless vortex
moving through stillness.

In Childhood, We Dream It into Being

At the end of my journey
there was a threshold.

If you stand very still,
they said,
you may discover
the thing you have come for.

I looked around cautiously.
Branches wove shadows
to lace.
Birds called back and forth
in languages I did not
understand.

Do you know what it
is like,
to struggle, to strive for centuries,
and still arrive
with empty hands?

Whisper of voices
circled in air.
The guides had hidden
clues under rocks,
behind waterfalls,
in green drenched branches.

But which? Desperately
I turned the ground leaves over,
one by one,
plunged my wrist
into the ripe loam of earth.

Finally I touched it,
the fragment I had buried there
so long ago,

and I remembered
the child at play,
the singing root,
the silver ribbon fixed
to the velvet pouch
whose lettering read,
Here is the treasure that waits,
the gift that wants to be found.

The Difficulty of Return

When I first got back,
I thought people would
wish to listen,
moved by my unlikely tale.

Soon I saw that to them I was
mere pariah, outcast,
traveler from a far country
no one had ever heard of,
much less believed in.

These goods I brought home
were invisible to all
but the most discerning eye.

My recitals, my celebrations
and laments of what transpired,
a dumb-show
to all but the most
finely tuned ear.

Now I am ringed by a halo of silence,
and move cautiously,
mouth closed
over this stone
I carry on my tongue.

Love Flings Us Forward

Yes, of course.

What good is it,
this feeling,
this ecstasy surging
in the limbs,
the heart,
abyss of bliss
which swallows you each day,
stunning consciousness,
silencing the tongue.

What purpose has been served
if the war, cancer,
oblivious parent or callous mate
with a blow or an unlucky turn of things
shatters the dream
which is your life,
weaving a dark stain
over your gleaming spirit garb.

The inscrutable
advances, whirls us like milk spores
over the rocks of the stream,
force echoing force,
life embracing life,
dashing us along
as if nothing mattered
but this, the hammering wave,
its forward rush,
this riot of love
across the weathering stone.

Oh, Yes

> *I wanted to make love until*
> *we were dust and ashes.*
> —Li~Po

That's it.
Dust and ashes,
and a flame in which we burn
always,
a crescent blaze of love,
surfaces dissolving,
until nothing is left of us
but a fine ash
at the core
and then that, too, melting
to a nothingness,
only a marker
where a somebody, a something, once was.

ADDITIONAL TITLES FROM HOHM PRESS

THE WOMAN AWAKE: Feminine Wisdom for Spiritual Life
by Regina Sara Ryan

Through the stories and insights of great women of spirit whom the author has met or been guided by in her own journey, this book highlights many faces of the Divine Feminine: the silence, the solitude, the service, the power, the compassion, the art, the darkness, the sexuality. Read about: the Sufi poetess Rabia (8th century) and contemporary Sufi master Irina Tweedie; Hildegard of Bingen, Mechtild of Magdeburg, and Hadewijch of Brabant: the Beguines of medieval Europe; author Kathryn Hulme *(The Nun's Story)* who worked with Gurdjieff; German healer and mystic Dina Rees...and many others.

Paper, 35 b&w photos; 520 pages, $19.95
ISBN: 0-934252-79-3

• • •

EVERYWOMAN'S BOOK OF COMMON WISDOM
by Erica Jen, Lalitha Thomas and Regina Sara Ryan

"Forget about being self-conscious. The truth is, nobody really cares. *They* are too busy being self-conscious." So advises this postcard-sized book of bright and profound sayings for women (and their curious male friends and spouses). These sometimes provocative, often inspiring "secrets" for success in business, sex, and family life are ideal reminders—great for posting on a refrigerator door, or sending in a letter to a friend. With over 100 years of combined wisdom, poet Erica Jen of San Francisco, and Arizona authors Regina Sara Ryan (*The Wellness Workbook,* Ten Speed Press; *The Woman Awake,* Hohm Press) and Lalitha Thomas (*10 Essential Herbs,* Hohm Press) offer their unique and sometimes quirky views of life in this collection of short aphorisms about how to be happy, and how to live sanely in a world gone mad.

Paper, 134 pages, $6.95 ISBN: 0-934252-52-1

**TO ORDER PLEASE SEE ACCOMPANYING ORDER FORM
OR CALL 1-800-381-2700 TO PLACE YOUR ORDER NOW.**

ADDITIONAL TITLES FROM HOHM PRESS

CRAZY AS WE ARE
Selected Rubais from the Divan-i-Kebir
of Mevlana Celaleddin Rumi
Introduction and Translation by Dr. Nevit O. Ergin

This book is a collection of 128 previously untranslated *rubais*, or quatrains (four-line poems which express one complete idea), of the 13th-century scholar and mystic poet Rumi. Filled with the passion of both ecstasy and pain, Rumi's words may stir remembrance and longing, or challenge complacency in the presence of awesome love. Ergin's translations (directly from Farsi, the language in which Rumi wrote) are fresh and highly sensitive, reflecting his own resonance with the path of annihilation in the Divine as taught by the great Sufi masters.

Paper, 88 pages, $9.95 ISBN 0-934252-30-0

• • •

IN PRAISE OF RUMI
by Lee Lozowick, and others
Introduction by Regina Sara Ryan

Once a great Turkish scholar and theologian, Jelaluddin Rumi lost his heart to a wandering beggar, Shams E Tabriz, in whom he saw the face of God. His poetry extols his love and longing—for his beloved teacher, and for the Divine, alive in all things. *In Praise of Rumi* is a book of ecstatic poetry. It is an expression from the same chamber of the heart in which Rumi danced over 700 years ago. A book for those who know what it means to have a wounded heart, *In Praise of Rumi* celebrates the bittersweet pain and pleasure of tasting the raw Divine.

Paper, 80 pages, $8.00 ISBN: 0-934252-23-8

**TO ORDER PLEASE SEE ACCOMPANYING ORDER FORM
OR CALL 1-800-381-2700 TO PLACE YOUR ORDER NOW.**

ADDITIONAL TITLES FROM HOHM PRESS

RENDING THE VEIL: Literal and Poetic Translations of Rumi
by Shahram T. Shiva Preface by Peter Lamborn Wilson

With a groundbreaking transliteration, English-speaking lovers of
Rumi's poetry will have the opportunity to "read" his verse aloud,
observing the rhythm, the repetition, and the rhyme that Rumi him-
self used over 800 years ago. Offers the reader a hand at the magical
art of translation, providing a unique word-by-word literal transla-
tion from which to compose one's own variations. Together with
exquisitely-rendered Persian calligraphy of 252 of Rumi's quatrains
(many previously untranslated), Mr. Shiva presents his own poetic
English version of each piece. From his study of more than 2000 of
Rumi's short poems, the translator presents a faithful cross-section
of the poet's many moods, from fierce passion to silent adoration.
"Faithfully polished translations." – *Publisher's Weekly*

Cloth, 280 pages, $27.95 ISBN: 0-934252-46-7

• • •

THE MIRROR OF THE SKY:Songs of the Bauls of Bengal
Translated by Deben Bhattacharya

Baul music today is prized by world musicologists, and Baul lyrics
are treasured by readers of ecstatic and mystical poetry. Baul music,
lyrics, and accompanying dance reflect the passion, the devotion and
the iconoclastic freedom of this remarkable sect of musicians and
lovers of the Divine, affectionately known as "God's troubadours."
 The Mirror of the Sky is a translation of 204 songs, includ-
ing an extensive introduction to the history and faith of the Bauls,
and the composition of their music. It includes a CD of authentic
Baul artists, recorded as much as forty years ago by Bhattacharya, a
specialist in world music. The current CD is a rare presentation of
this infrequently documented genre.

Paper, 288 pages, $24.95 (includes CD)
ISBN: 0-934252-89-0 CD sold separately, $16.95

**TO ORDER PLEASE SEE ACCOMPANYING ORDER FORM
OR CALL 1-800-381-2700 TO PLACE YOUR ORDER NOW.**

ADDITIONAL TITLES FROM HOHM PRESS

TAO TE CHING FOR THE WEST
by Richard Degen

A new rendition of the revered classic, *Tao Te Ching*, this sensitive version offers a contemporary application of Eastern wisdom to the problems created by modern Western living.

Paper, 120 pages, $9.95 ISBN: 0-934252-92-0

• • •

COLOR YOUR HAIR RED
A Story of One Woman's Liberation
by Polly Doge

Unembarrassed prose and sure dialogue venture into the areas of sexuality, relationships, the creative process, the traumas of childbirth in the technological age and the secrets that women know about men . . . and about themselves. A dream-like reflection upon the author's life and times, the book follows the threads of several realities weaving together a raw, sensitive, and fascinating chronicle of one woman's liberation.

". . .cruising along on brutal honesty. . .Presents the same thrill as reading someone's journal. . .intensely private and forthright."
— Publisher's Weekly

Paper, 128 pages, $11.95 ISBN:0-934252-59-9

TO ORDER PLEASE SEE ACCOMPANYING ORDER FORM OR CALL 1-800-381-2700 TO PLACE YOUR ORDER NOW.

ADDITIONAL TITLES FROM HOHM PRESS

THE WAY OF POWER
by RedHawk

Nominated for the 1996 Pulitzer Prize in Literature, RedHawk's poetry cuts close to the bone whether he is telling humorous tales or indicting the status-quo throughout the culture. "This is such a strong book. RedHawk is like Whitman: he says what he sees..." William Packard, editor, *New York Quarterly.*

Paper, 96 pages, $10.00 ISBN: 0-934252-64-5

• • •

THE ART OF DYING
by RedHawk

In this collection of 90 new poems, RedHawk scrutinizes a range of vital subjects from children, nature and family, to God, politics and death. "An eye-opener; spiritual, native, populist. RedHawk's is a powerful, wise, and down-home voice."

Paper, 120 pages, $12.00 ISBN: 0-934252-93-9

TO ORDER PLEASE SEE ACCOMPANYING ORDER FORM OR CALL 1-800-381-2700 TO PLACE YOUR ORDER NOW.

ADDITIONAL TITLES FROM HOHM PRESS

FOR LOVE OF THE DARK ONE: SONGS OF MIRABAI
Revised edition
Translations and Introduction by Andrew Schelling

Mirabai is probably the best known poet in India today, even though she lived 400 years ago (1498-1593). Her poems are ecstatic declarations of surrender to and praise of Krishna, whom she lovingly calls "The Dark One." Mira's poetry is as alive today as it was in the sixteenth century—a poetry of freedom, of breaking with traditional stereotypes, of trusting completely in the benediction of God. It is also some of the most exalted mystical poetry in all of world literature, expressing her complete surrender to the Divine, her longing, and her madness in love. This revised edition contains the original 80 poems, a completely revised Introduction, updated glossary, bibliography and discography, and additional Sanskrit notations.

Paper, 128 pages, $12.00 ISBN: 0-934252-84-X

• • •

GRACE AND MERCY IN HER WILD HAIR
Selected Poems to the Mother Goddess
by Ramprasad Sen
Translated by Leonard Nathan and Clinton Seely

Ramprasad Sen, a great devotee of the Mother Goddess, composed these passionate poems in 18th-century Bengal, India. His lyrics are songs of praise or sorrowful laments addressed to the great goddesses Kali and Tara, guardians of the cycles of birth and death.

Paper, 120 pages, $12.00 ISBN 0-934252-94-7

TO ORDER PLEASE SEE ACCOMPANYING ORDER FORM
OR CALL 1-800-381-2700 TO PLACE YOUR ORDER NOW.

RETAIL ORDER FORM FOR HOHM PRESS BOOKS

Name _____ Phone () _____
Street Address or P.O. Box _____
City _____ State _____ Zip Code _____

QTY	TITLE	ITEM PRICE	TOTAL PRICE
	THE WOMAN AWAKE	$19.95	
	EVERYWOMAN'S BOOK...	$6.95	
	CRAZY AS WE ARE	$9.95	
	IN PRAISE OF RUMI	$9.95	
	RENDING THE VEIL	$27.95	
	MIRROR OF THE SKY (WITH CD)	$24.95	
	MIRROR OF THE SKY (CD ONLY)	$16.95	
	TAO TE CHING	$9.95	
	COLOR YOUR HAIR RED	$11.95	
	THE WAY OF POWER	$10.00	
	THE ART OF DYING	$12.00	
	FOR LOVE OF THE DARK ONE	$12.00	
	GRACE & MERCY IN HER WILD HAIR	$12.00	
	MARROW OF FLAME	$12.00	

Surface Shipping Charges

1st book	$4.00
Each additional item	$1.00

Subtotal	
Shipping	
Total	

SHIP MY ORDER
☐ Surface U.S. Mail—Priority ☐ UPS (Mail + $2.00)
☐ 2nd-Day Air (Mail + $5.00) ☐ Next-Day Air (Mail + $15.00)

METHOD OF PAYMENT
☐ Check or M.O. Payable to Hohm Press,
 P.O. Box 2501, Prescott, AZ 86302
☐ Call 1-800-381-2700 to place your credit card order
☐ Or call 1-520-717-1779 to fax your credit card order
☐ Information for Visa/MasterCard order only:
Card #_____ – _____ – _____ – _____
Expiration Date_____

Visit our Website to view our complete catalog:
www.hohmpress.com
ORDER NOW! Call 1-800-381-2700
or fax your order to 1-520-717-1779.
(Remember to include your credit card information.)

ABOUT THE AUTHOR

Dorothy Walters has been previously published in various journals and anthologies, including *The Divine Feminine* by Andrew Harvey and Anne Baring (1996). Her experience of awakening consciousness is described in *The Fiery Muse* by Teri Degler (1996). At present she is completing an autobiographical account entitled *Unmasking the Rose: A Journal of Kundalini Awakening*. She lives and writes in San Francisco.

Dorothy is available for poetry readings and lectures. Contact her at: sfreader@hotmail.com